THIS BOOK BELONG TO

..........................

..........................

I LOVE DRAWING

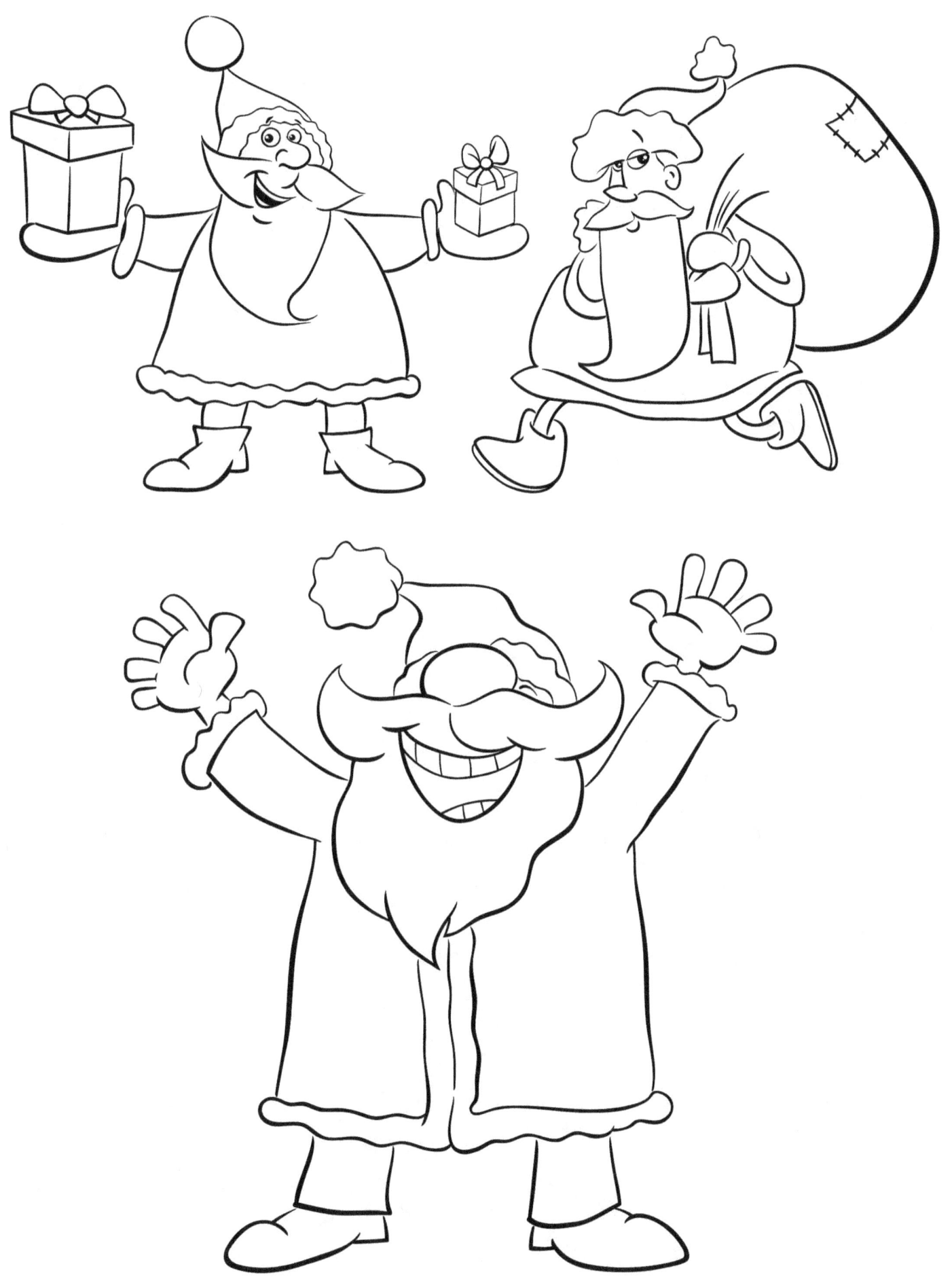

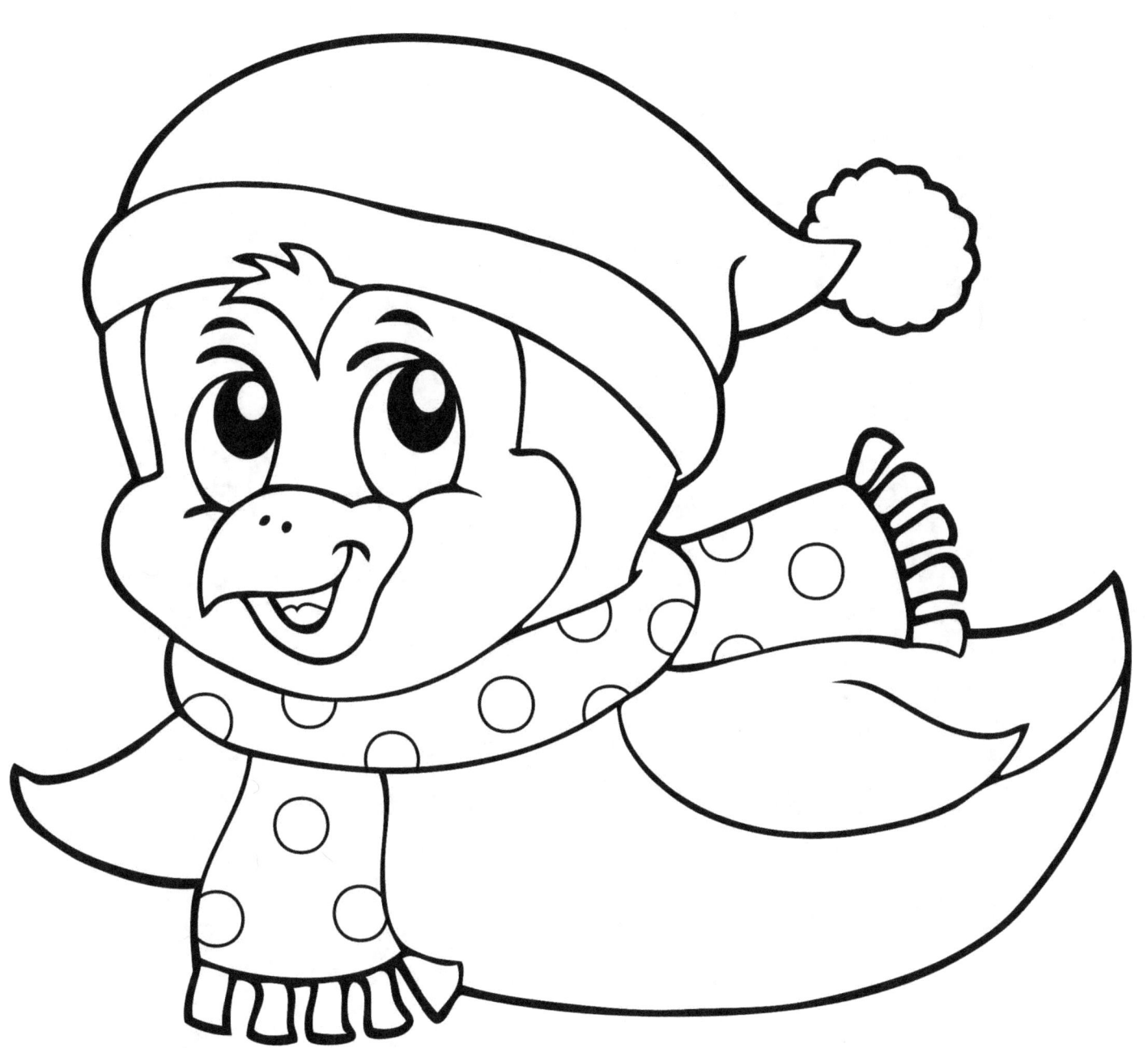

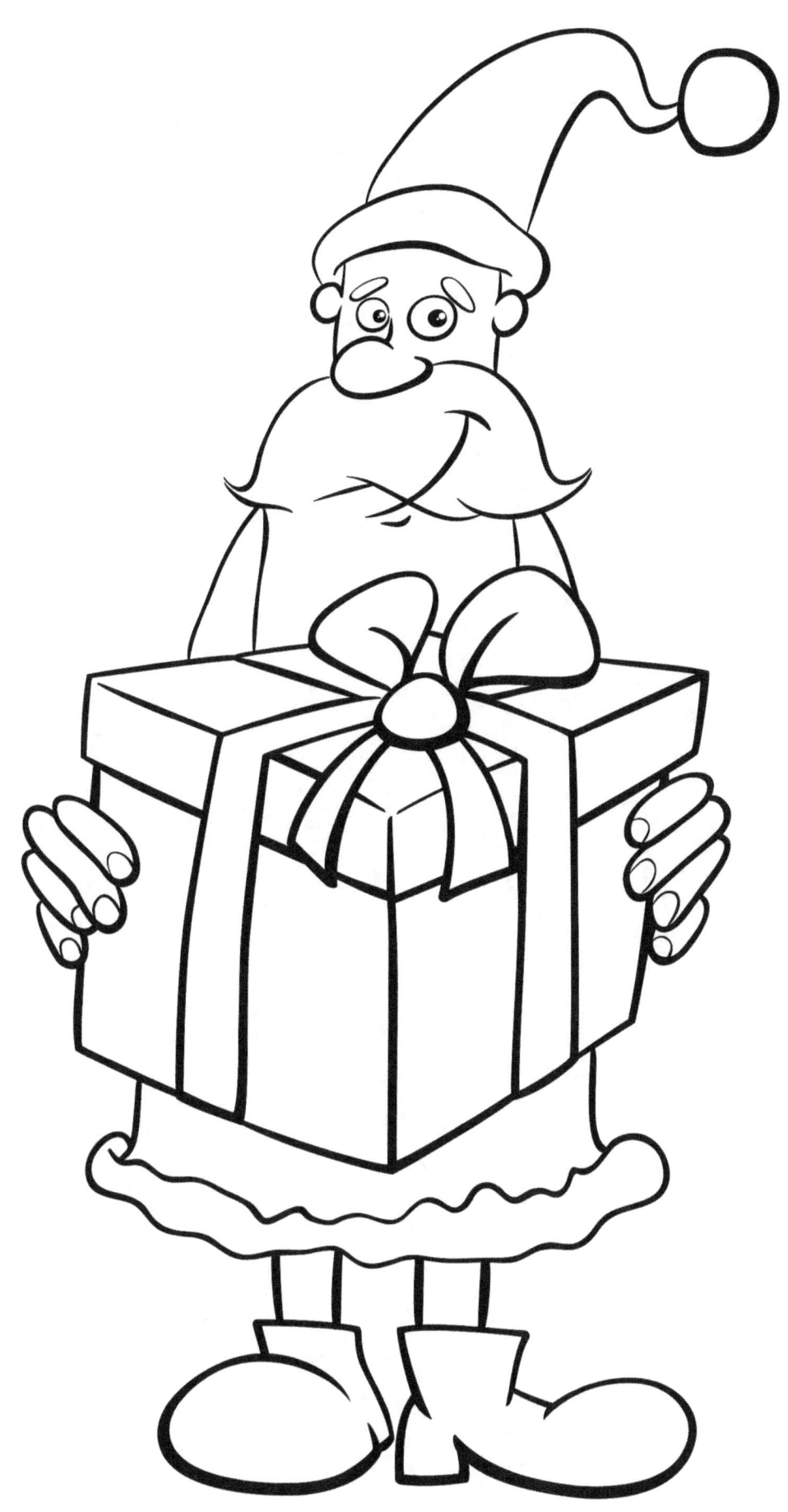

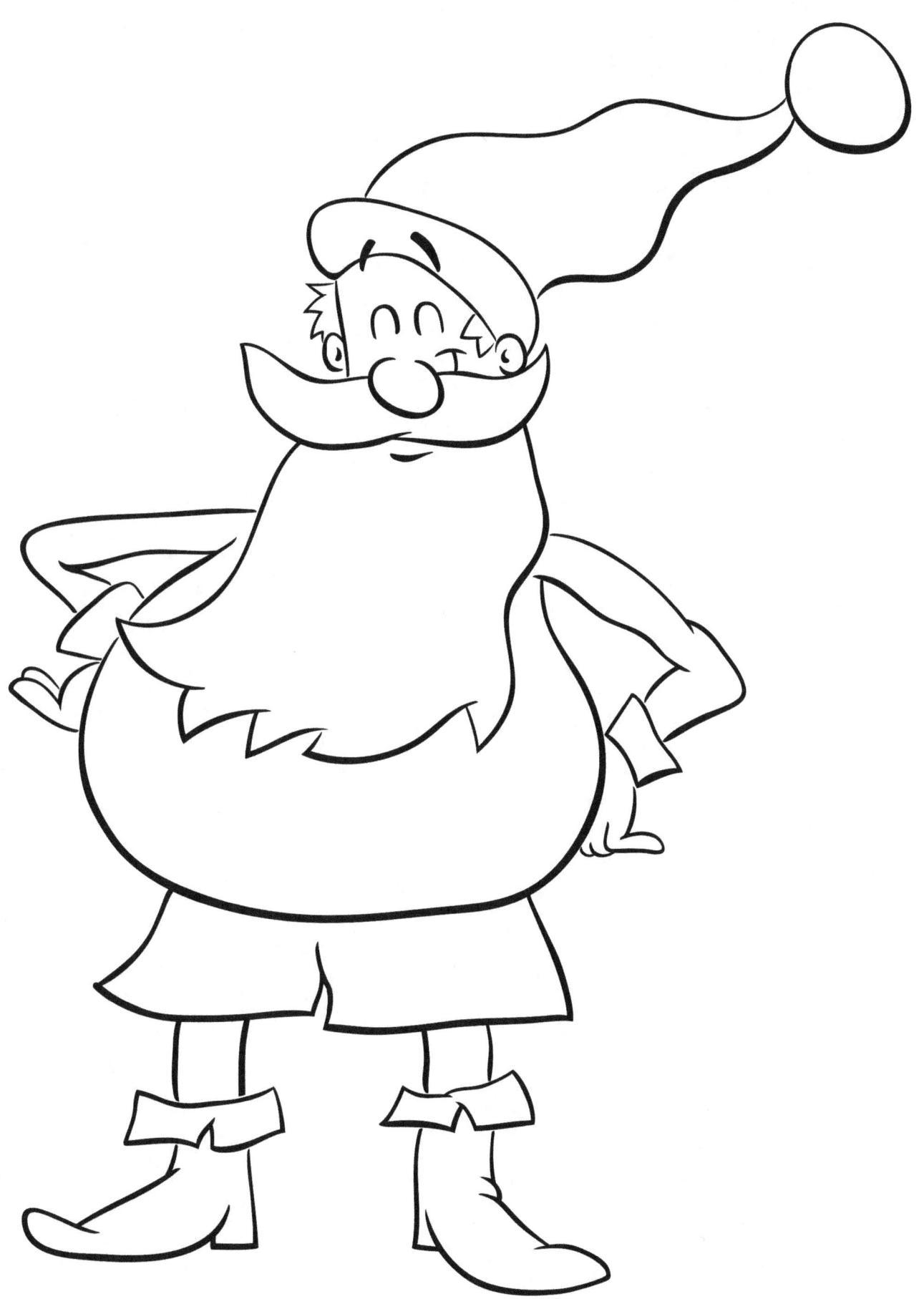

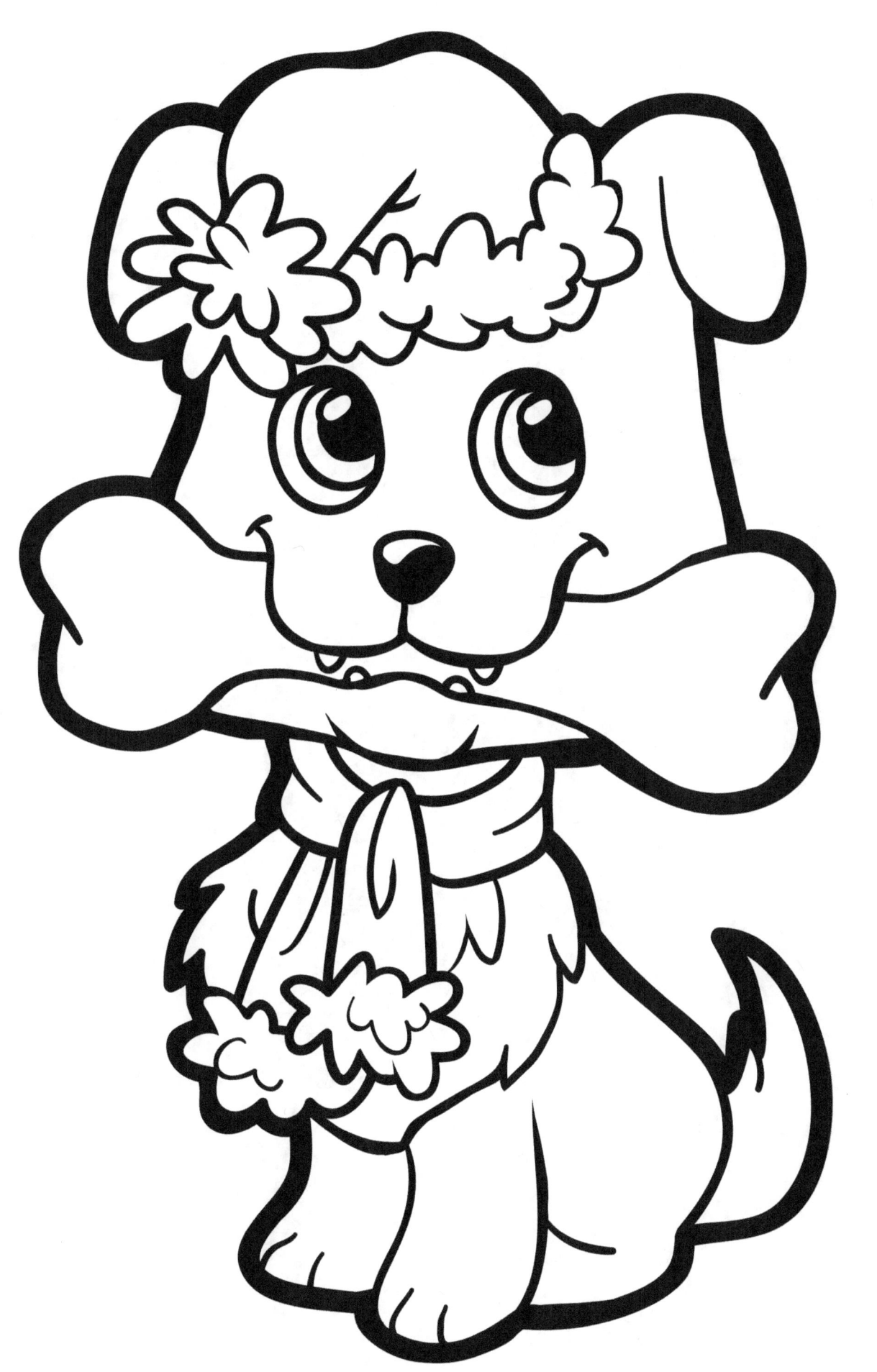

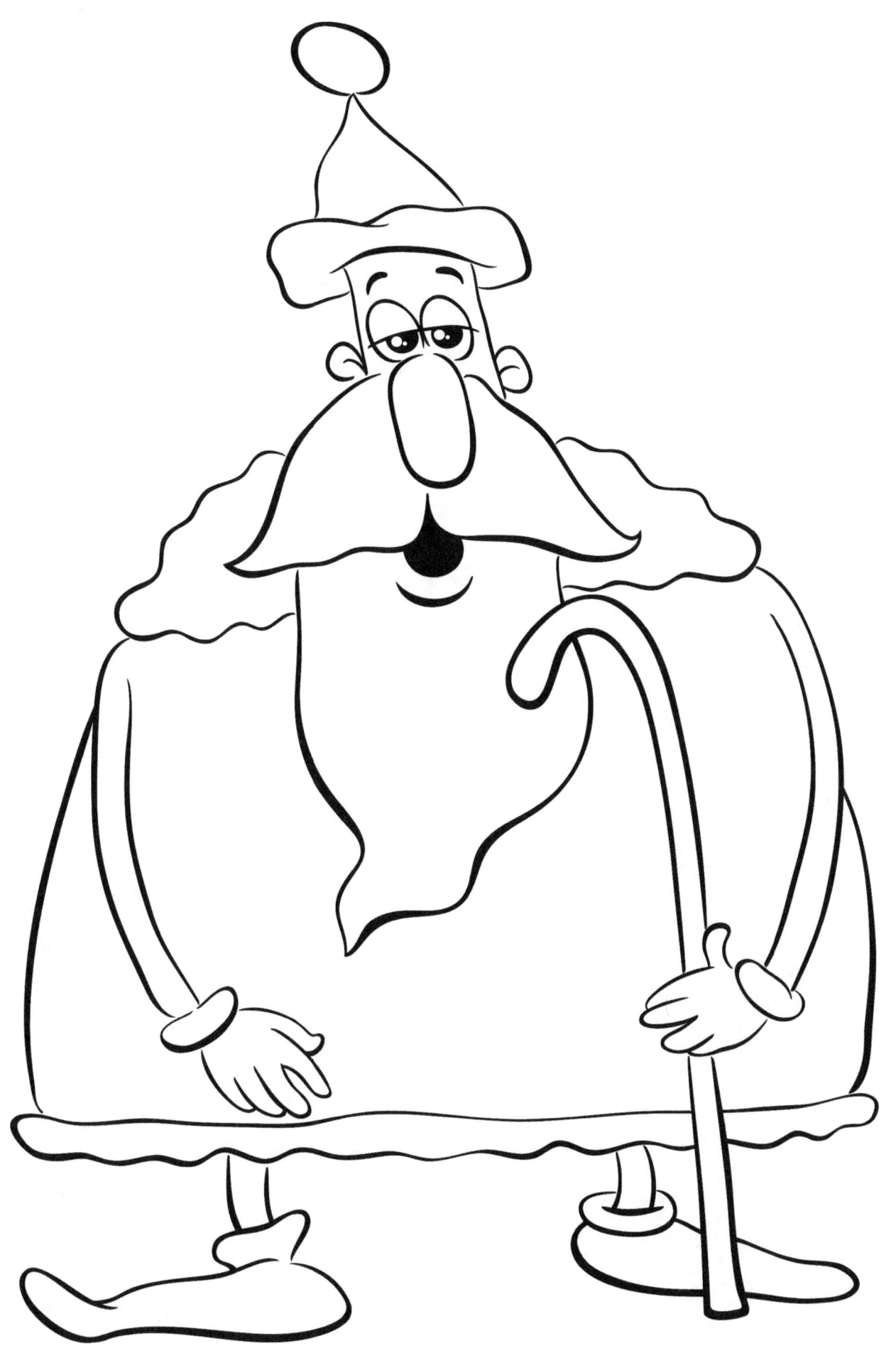

www.ingramcontent.com/pod-product-compliance
Lightning Source LLC
Chambersburg PA
CBHW081448220526
45466CB00008B/2556